Through the Looking Glass

Women and Self-Representation in Contemporary Art

Palmer Museum of Art The Pennsylvania State University, University Park, Pennsylvania
Distributed by The Pennsylvania State University Press

Published on the occasion of the exhibition Through the Looking Glass: Women and Self-Representation in Contemporary Art held at the Palmer Museum of Art, October 21, 2003–January 25, 2004

Published with support from the George Dewey and Mary J. Krumrine Endowment

Designed by the Penn State Department of University Publications
U.Ed. ARC 03-485
Printed by Payne Printery, Inc.

ISBN 0-911209-60-3

Through the Looking Glass

Women and Self-Representation in Contemporary Art

Table of Contents

Through the Looking Glass

Women and Self-Representation in Contemporary Art

Palmer Museum of Art

Foreword

Palmer Museum of Art director, Jan Muhlert, and I are delighted to welcome Dr. Sarah K. Rich as a guest curator for *Through the Looking Glass: Women and Self-Representation in Contemporary Art.* Dr. Rich is an assistant professor in the Department of Art History at Penn State and teaches courses in American and contemporary art, as well as in critical theory and aesthetics. Her energy and enthusiasm for this exhibition have been contagious; her essay for this catalogue, as expected, is trenchant and probing. We thank her very much for her contributions, particularly coming as they did during a much-coveted sabbatical year.

This loan exhibition of contemporary painting, sculpture, and video grew out of Penn State's Women's Self-Representation in the Visual Arts and Writing Project, an interdisciplinary research forum on the subject of gender and historical constructions of selfhood that was initiated in 2001. *Through the Looking Glass* focuses on the particular opportunities and challenges faced by women artists when they produce self-portraits. Self-portraiture has long been a staple element in the construction of an artist's identity, for the genre has historically helped to define the artist *as artist* (or at least *as painter* or *as sculptor*). The tautology offered by self-portraiture—that the artist is an artist because s/he is making the picture, even as the picture documents the person as an artist after the fact—has allowed for a rich exploration of selfhood by many artists. Consequently, over the past few decades, as more women have had the opportunity to become and to succeed as artists, they have used self-portraiture as a means of thinking through their identity as women and as artists. But they have also taken this opportunity to examine the ways in which the conventions of self-portraiture and representation in general are challenged by the very presence of women in the double position of subject/object of the self-portrait.

The double positioning of artist as both maker and object informs Julie Heffernan's *Self Portrait as Woman Recovering from Effects of Male Gaze (What's Underneath),* 1992, one of the highlights of the Palmer Museum of Art's collection of contemporary painting. Heffernan's old master technique belies the late twentieth-century theoretical concerns embedded within this lush still life *cum* portrait, whose title might very well stand as an apt description of all the works in the exhibition. Like many of the artists represented in *Through the Looking Glass,* Heffernan seeks to disempower the hegemonic male gaze, offering up her multifaceted, contingent self as the object of her own intense scrutiny. Directly on the surface of the canvas, Heffernan has inscribed bits of text documenting the fragmented complexities of the life of "Venus" (the male object of aesthetic contemplation *par excellence*): "Venus sitting in a dog chair. Venus cracking peanuts with her teeth…Venus making bad jokes…Venus trying to make nice to hear her own voice speak and know the sound of it…" Like Heffernan's dethroned, yet enlightened ancient goddess, the women in this exhibition seek to know their own voice and recognize their own body through the refracted agency of the looking glass.

Many people have contributed to the success of this exhibition and its accompanying catalogue. For their help in securing photographic and video materials, we especially thank Shelley Lee, Estate of Roy Lichtenstein; Marianne McElwee, Picture Library Assistant, Royal Collection Enterprises; Danielle DuClos, Robert Mapplethorpe Foundation; Owen Smith, Mattress Factory; Sabrina Gschwandtner and Rebecca Cleman, Electronic Arts Intermix; Jessica David, Art Resource, New York; and Dick Ackley, Campus Photography, Penn State. Loans of objects were generously facilitated by Natalia Mager, Luhring Augustine, New York; George Adams, George Adams Gallery, New York; Sheri L. Pasquarella, Gorney Bravin + Lee; Mitchell Algus, Mitchell Algus Gallery; and Amy Young, Robert Miller Gallery. Betsy Johnson and Gabriella Szalay, graduate assistants at the museum, both proved themselves indispensable in the final stages of planning. We would also like to acknowledge our private lenders, Alexis Shein and Patricia A. Bell, who graciously lent prized pieces from their collections. The Women's Self-Representation Project provided financial support through the auspices of a grant from the Institute for the Arts and Humanities at Penn State. Special thanks are directed to Dr. Mary Lou Krumrine, who made this publication possible through the George Dewey and Mary J. Krumrine Endowment.

Joyce Henri Robinson, curator

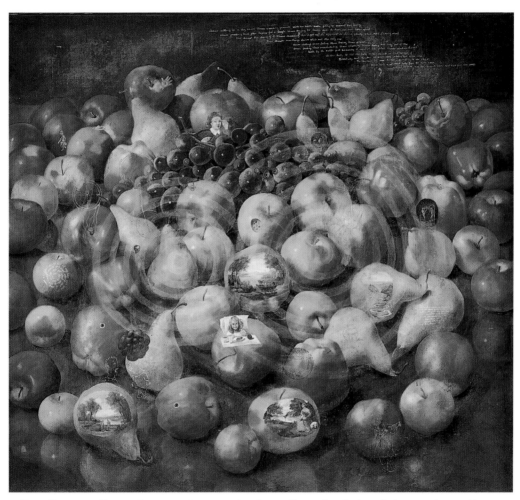

Julie Heffernan, *Self Portrait as Woman Recovering from Effects of Male Gaze (What's Underneath)*, 1992. Oil on canvas, 67 1/2 x 68 1/2 inches. Palmer Museum of Art. Gift of Jonathan Kalb, 99.15

Ana Mendieta, Untitled from the "Silueta" series, 1976. Color c-print, 16 x 20 inches. Palmer Museum of Art, 2002.1.1. Courtesy of the Estate of Ana Mendieta and Galerie Lelong, New York

"And now, who am I?"

—Alice, in *Through the Looking Glass*

Early in her book *Am I That Name?: Feminism and the Category of "Women" in History,* historian Denise Riley summarizes the predicament that is a central concern of this exhibition. "To put it schematically," Riley says, "'women' is historically, discursively constructed, and always relatively to other categories which themselves change; 'women' is a volatile collectivity in which female persons can be very differently positioned, so that the apparent continuity of the subject of 'women' isn't to be relied on…"[1]

For some, Riley's might seem a counterintuitive statement. Viewers and readers who are women may certainly enjoy a sturdy (rather than "volatile") sense of themselves through their gender, and may also derive empowerment from their identities as women. Nevertheless, Riley's understanding of gender opens up an opportunity to appreciate multiple kinds of "women" flourishing all around us. It's not difficult to look about and see other women who embody their genders differently. A college student might define her gender according to rituals of consumption and social interaction that are entirely different from those engaged by women of other generations, occupations, and communities. Many of us approach our respective genders with the benefit of different personal experiences—ethnic, economic, linguistic, sexual—that inflect our definitions of ourselves. And, for all those differences that currently operate among women now, those differences multiply when we think about the ways in which women have defined themselves through history. It is in part these *differences* that Riley hopes to emphasize. She reminds us that "women" is, in effect, a shorthand term that summarizes a plethora of identities.

Riley was part of a theoretical movement in the 1980s that attempted, and continues to attempt, a departure from more essentializing waves of feminism in the 1970s, which often sought to valorize (stereo)typical feminine temperaments, anatomy, or work. Those earlier phases of feminism[2] often did the important work of arguing for the inclusion of women and traditionally feminine attributes in canons of cultural history, while they also questioned the very means by which previous canons and historical narratives were formed to the exclusion or denigration of women.[3] Nevertheless, in the last two decades many feminists (many of them art historians) have been more devoted to destabilizing the categories of gender that allowed such discrimination against women in the first place. Historians like Riley have, to

that end, emphasized the "volatility" of gender, arguing that typical "womanly" attributes cannot be crystallized because they have changed over time and operate differently in various contexts.[4]

All the artists in this exhibition explore the consequences of the instability of the category "women." When they make their own gender a focus of their work, at least within their self-representation, they tend to question, rather than affirm, the status of that gender. They test its boundaries, and they see the representation of their gendered bodies as a challenge, rather than as a given.

Of course, the contingency of womanliness is not entirely new to the domain of women's self-portraiture. Early on women artists perceived the disruptive

effect that their gender posed when introduced into conventions of self-representation.

Artemesia Gentileschi, for example, famously addressed the predicament of women's self-portraiture in 1630. The daughter of a painter, and herself the author of several history paintings that address the social position of women in society and in painting, Gentileschi produced a self-portrait that diverged from the usual conventions of the genre. The piece works on the tautology offered by self-portraiture—that the artist is an artist in part because she is making a picture, even as the picture documents the person as an artist after the fact. Her means of addressing such a tautology is, however, discomfiting. Typically an artist faces the viewer in a self-portrait, in a posture of direct address. Instead,

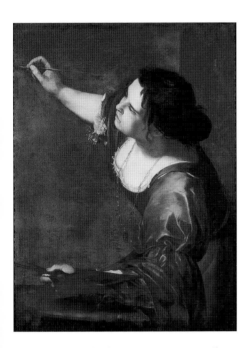

Artemesia Gentileschi, *La Pittura*, 1630. Oil on canvas, 38 x 29 inches. The Royal Collection ©2003, Her Majesty Queen Elizabeth II

Gentileschi looks to the side, ostensibly at the canvas on which she is working—a confusing shift, given that the canvas is probably the painting at which we are currently looking. She is, in other words, an artifact of her own making, finished for our gaze, but also, contradictorily, in a state of perpetual self-creation.

That self-creation, however, is all the more complex, as Gentileschi struggled with the definition of her self dialogically, against typical definitions of gender in her day. She wears around her neck a picture of a mask, which was, by the sixteenth century, the allegorical symbol of painting. In emblem books of the period, the art form of painting was symbolized by a generic woman wearing such a necklace, or by a woman wearing such a mask, much in the way that the Statue of Liberty now symbolizes, with the conceit of a generic woman holding a torch, the larger principle of freedom.[5] In the process, Gentileschi referenced the troubling tradition of using women to represent generalities (such as "Painting" or "Freedom"), while men, more frequently, appeared in painting as historic individuals—heroes or rulers. Indeed, until the period in which Gentileschi worked, women were more often associated with painting according to such generalities. They were considered to be muses of painting, or symbols for painting, rather than, for example, professional painters. So Gentileschi's self-representation explores this dual role that women had occupied in painting and as painters until that point, as she embodies the general principle of painting in the allegorical sense even as she asserts her own professional identity as an individual painter.

Though most of the works in this exhibition likewise view self-representation as a problematic enterprise, few are such explicit self-portraits. Rather, most of them use self-representation as a means to another end—as, for example, a commentary on the larger social structures through which "selves" are created. Such is the project of one of the earliest pieces in the exhibition, Martha Rosler's *Self-Portrait I,* part of her "Body Beautiful", (a.k.a. "Beauty Knows No Pain") series of 1966–1972.[6] In the mid-1960s, Martha Rosler used such collages as a means of disrupting ideologies at work in popular imagery such as advertising and war photography, and she occasionally used techniques of self-portraiture to question relationships between women's bodies and consumer culture.

Self-Portrait I features a sparkling Xanadu of mod design. The style of the image, in which an unoccupied room is photographed from a distant point so that the maximum amount of the décor is visible, is easily recognizable as the kind of illustration that usually accompanies an interior decoration spread in a magazine—a kind of spread that is meant to tantalize the reader and offer up an example of domestic chic that most people will never be able to achieve. But Rosler has chosen an image that is as disturbing as it is seductive. In many respects, this is less a "house beautiful" than a vertiginous house of mirrors. In the blindingly white room, light enters from between the patterned shutter slats and reflects off the angled mirrors on the right, only to be refracted again in the crystal decanters of the

foreground. The crisp lines of the furniture float above a dizzying tile work pattern. With the busy interactions of the furniture, walls, and reflected light, the exact dimensions of the room are virtually impossible to ascertain.

The "self-portrait" portion of the collage serves to further disrupt the space. It is a photo of Rosler herself, resting a hand against a car window, looming a bit larger than life over the expensive furniture. The placement of the portrait at the focal point of the image allows the image to function as a typical "the lady of the house" portrait, such as one might find in an upscale home, and Rosler's sunglasses seem appropriate for someone who enjoys such a life of luxury. Still, Rosler doesn't quite pass in this environment. She's not quite coiffed enough to own or be

associated with this sort of house. Her car is too plain, her clothes not sufficiently expensive. And the style of the photographic portrait itself, a snapshot of Rosler on the road in southern California, also looks a bit too casual for the surroundings.

There are other kinds of interior design to which Rosler is alluding here. In the mid-fifties, popular magazines such as *Life* and *Time,* as well as art magazines such as *ARTnews,* had begun to include interior shots of art collections as they were displayed in domestic spaces.

A 1961 photograph of Jackson Pollock's *Blue Poles* in collector Ben Heller's Manhattan apartment, for example, appeared in *ARTnews* and argued for the happy coexistence of modern design and contemporary art,

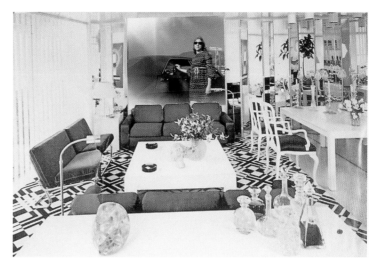

Martha Rosler, *Self-Portrait I*, from the "Body Beautiful" (a.k.a. "Beauty Knows No Pain") series, 1966–72. C-print, 14 3/4 x 19 1/2 inches. ©Martha Rosler, 1966–72. Courtesy Gorney Bravin + Lee, New York

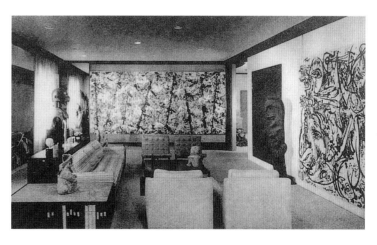

Ben Heller's Living room with Jackson Pollock's *Blue Poles*, *ARTnews*, September 1961

while advocating the continued patronage of American artists by American collectors.[7] The photograph of the painting in this living room advertises Heller's wealth and adventurous taste and demonstrates the extent to which a collector might achieve social status through the acquisition of works of art. In the wake of such post-war photographic traditions, Rosler's presence in *Self-Portrait I* assumes a doubled quality. Her presence in the picture simultaneously makes her out to be the wealthy patron of the house—a sort of famous woman collector like Ethyl Scull or Marcia Weisman. Given that she does not quite pass in such a role, however, and given that we know she is the artist (not patron) constructing the entire image, her self-portrait points

to the artist's role as an agent through whom such wealthy spaces are constructed. It is through the acquisition of artistic efforts such as those by Pollock and Rosler, in other words, that the wealthy are able to declare their social position. But while Pollock's art was, in essence, co-opted for such an enterprise (bought by Heller for the purposes of upping his social capital), Rosler takes a more active role in investigating the relationship between artist and patron. She takes control of the entire scenario. She crafts the domestic space proper through her collage. Her body, rather than just a painting she has made, also physically appears at the center of the work. In masquerading (unconvincingly) as patron as well as artist, she

confuses the power relationship between the buyer and the bought. And in the process, she questions the ways in which artists may, or may not, comment on their own potential complicity in producing visual signs of wealth.

The self-representation by Japanese artist Yayoi Kusama from the mid-sixties is slightly more self-revelatory, though it too depends on social and artistic conventions for its effect. In this self-portrait montage, Kusama reclines on one of her "aggregation couches"—furniture to which she appended a proliferation of soft, phallic forms. Behind her is an example of one of her "infinity net" paintings, and in the lower register of the image, Kusama has pasted a close-up photograph of wagon wheel macaroni.

Hospitalized for mental illness since 1975, Kusama has suffered from hallucinations and obsessive-compulsive symptoms for most of her life, and her furniture and repetitious paintings of dots have been attributed to her psychological state. In speaking about her work, Kusama has noted:

…you might say that I came under the spell of repetition and aggregation. My nets grew beyond myself and beyond the canvases I was covering with them. They began to cover the walls, the ceiling, and finally the whole universe. I was always standing at the center of the obsession, over the passionate accretion and repetition inside of me.[8]

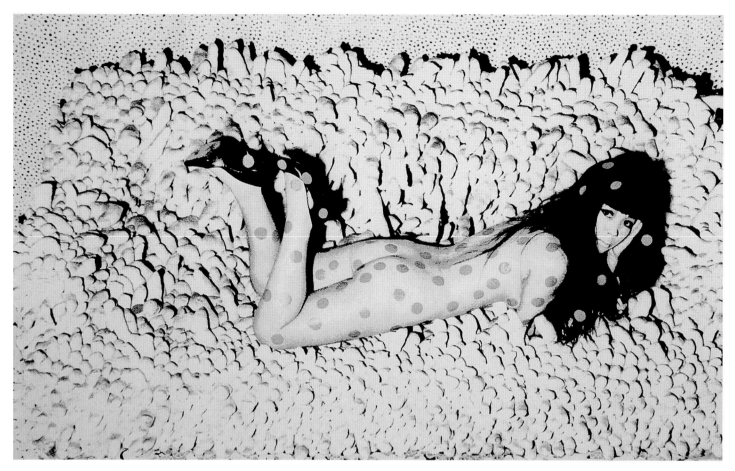

Yayoi Kusama, *Multi-fabrics by Yayoi Kusama*, 2002. Fabric cover, collage with photograph by Hal Reiff of the artist reclining on *Accumulation No. 2*, 1966, cotton and polyester, 86 5/8 x 110 1/4 inches. ©Yayoi Kusama, Courtesy Robert Miller Gallery, New York

Kusama thus expresses a disintegration of self through the infinity net paintings and aggregation furniture. Through the infinity nets, the world becomes increasingly atomized and dispersed, and with the applications of dots to her body, Kusama yields herself up to this dispersion. Her body, her ego, disintegrates into the environment and she loses the sense of individual selfhood that is the cornerstone of western subjectivity and "sanity."

Beyond the psychological trauma that Kusama's art might reveal, her work, and in particular her self-portrait, is also a clever reworking of Pop art—one of the dominant modes of art making during the period in which the portrait was made.

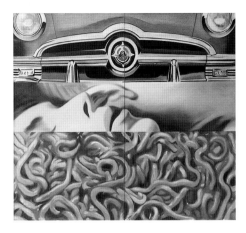

James Rosenquist, *I Love You With My Ford*, 1961. Oil on canvas, 82 3/4 x 93 1/2 inches. Moderna Museet, Stockholm. ©James Rosenquist/Licensed by VAGA, New York

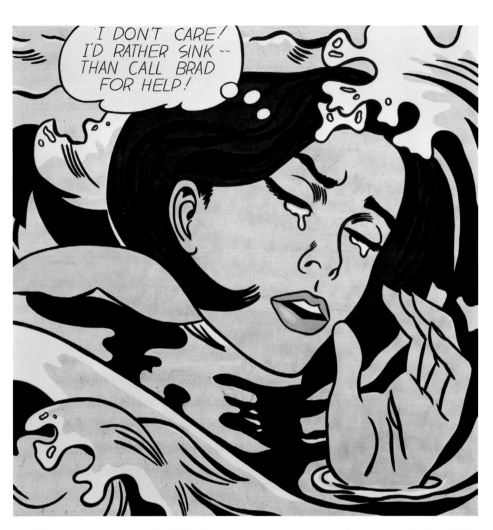

Roy Lichtenstein, *Drowning Girl*, 1963. Oil and synthetic polymer paint on canvas, 67 5/8 x 66 3/4 inches. The Museum of Modern Art, New York. ©Estate of Roy Lichtenstein

The soft phalluses of Kusama's work are often compared to the flaccid forms of Claes Oldenburg's sculpture,[9] but there are many other Pop qualities to her self-portrait. Kusama's polka dots, for example, function as did the benday dots of Roy Lichtenstein's paintings.

Lichtenstein's *Drowning Girl* of 1963 satirizes the melodrama of soap operas and serial comics, turning the drama of the title figure's potential suicide into a high camp performance. The silk-screened benday dots of the image reference the low-budget techniques used in comic book

reproductions, collapsing the difference between high art and more popular media. Kusama's choice of dots in this context in essence turns her into a sort of real, live drowning girl. By virtue of her well-known psychological distress, the contemporary

viewer of the image could see Kusama's self-disintegration through dots as similar to that of Lichtenstein's heroine. But Kusama then puts a twist on Lichtenstein's character. The camp value of the *Drowning Girl* depends on Lichtenstein's ironic

appropriation of an otherwise serious subject, and the woman in his image shows an (albeit highly coded) expression of distress on her face. By contrast, Kusama shows no such distress. Rather, her posture is one of sexual availability, not despair. Indeed, with such a posture the dots on her body, like many Pop devices, advertise her body. Just as Marilyn Monroe's beauty mark accented her full lips, Kusama's dots accent her young, otherwise blemish-free skin, and pitch her body to the viewer. In the process, Kusama ironizes Lichtenstein's irony, and transforms his benday dots—which in his work signify a reproducible self—into a playful sign of her own personal battle with identity.

The conceit of a pasta product in the lowest portion of the image also speaks to Pop conventions. James Rosenquist (with whom Kusama's work was exhibited at the Green Gallery in 1962) famously used the device in works such as *I Love You With My Ford* of 1961.

His pasta is of the lowest-grade Chef Boyardee variety, and was meant as a parody of Jackson Pollock's drip pictures of the fifties. In the process, Rosenquist suggested that gesture painting such as Pollock's, which had originally been considered a direct trace of Pollock's own personal turmoil, had become (and perhaps always was) a canned gimmick.

Just as she played with Lichtenstein's dots, Kusama also repersonalized Rosenquist's device. Claiming that the repetitious forms of the pasta on the floor were symbols of her "fear of food and sex,"[10] as well as of her general obsessive-compulsive condition, Kusama reclaimed the signifiers of commodity culture from Pop art and tried to insert them back into her intensely personal narrative. The resulting image straddles the personal and the public, the self as the seat of internal conflict and the self as a social construct that is always subject to co-optation by consumer culture.

Works in the exhibition that were produced decades after Kusama's piece continue this investigation of the commodified self. Produced in an era in which MTV was enjoying its first flush of success, Pipilotti Rist's 1986 video *I'm Not the Girl Who Misses Much,* for example, has often been read as a parody of misogynistic music videos.[11] In the work, a topless and wig-wearing Rist parrots the first line of the Beatles' tune

Happiness is a Warm Gun:

She's not a girl who misses much,
She's well acquainted with the touch of the velvet hand
Like a lizard on a window pane

The man in the crowd with the mulitcoloured mirrors on his hobnail boots
Lying with his eyes while his hands are busy working overtime
A soap impression of his wife which he ate and donated to the National Trust

I need a fix 'cause I'm going down, down to the bits that I left up town
Mother Superior jumped the gun

Happiness is a warm gun
Happiness is a warm gun
When I hold you in my arms, and I feel my finger on your trigger
I know no one can do me no harm
Because happiness is a warm gun (bang bang, shoot shoot)
Happiness is a warm—Yes it is—Gun...

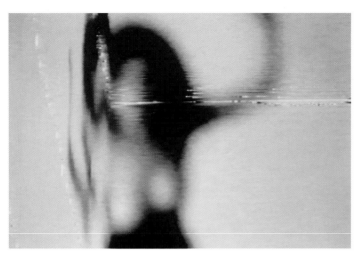

Pipilotti Rist, *I'm Not the Girl Who Misses Much*, 1986. Video still.
Courtesy of the artist and Luhring Augustine, New York

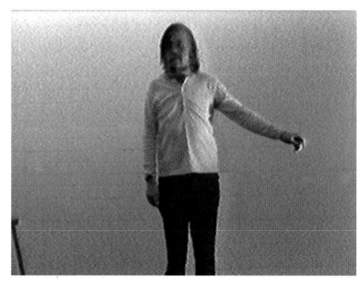

John Baldessari, *I Am Making Art*, 1971. Video still. Courtesy Electronic Arts Intermix (EAI), New York

The song is, admittedly, more evocative than explanatory. A montage of sexual imagery alluding to voyeurism, masturbation, and defecation in just a few stanzas, the song was inspired by a gun advertisement as well as John Lennon's relationship with Yoko Ono.[12] Lennon's "she" of the first line personifies a gun with a very sensitive trigger and accurate aim, though the pronoun can refer to a sort of generic object of onanistic fantasy as well as the more specific figure of Ono.

It is not unusual for a video artist to present him or herself repeating a single phrase ad nauseam. In John Baldessari's notorious 1971 video, *I Am Making Art,* for example, the artist spends close to twenty minutes repeating the title, and with each repetition he performs a small movement (such as bending an arm or a wrist)—suggesting that each gesture is ostensibly the art that he creates. Like many works of conceptual and video art that critiqued the expressive function of art as it had been associated

with movements such as Abstract Expressionism, Baldessari's piece emphasizes the banality of artistic gestures. Artistic production here becomes a repetitive, workmanlike process, a sort of alienated labor performed by a virtually autistic artist. And while Baldessari is the focus of the piece itself, the work ultimately tells the viewer nothing about his emotive state.

Rist's piece draws on this earlier conceptualist/video art tradition but socializes it a bit by associating

her repetitions with the visual and musical culture that one might witness on TV.

Rist's frantic repetitions of the first line give her an almost Delphic quality—she is a sort of pop culture Cassandra whose message has been dictated by deity John Lennon. In this oracular mode, Rist delivers a peculiar kind of speech specifically not of her own creation. Like anyone who sings a song written by someone else, Rist channels that artist's tune. Language becomes a found object, not composed but rather chosen by the singer because, one can assume, it applies to her condition. It is unclear what that condition is, however. In repeating "I'm not the girl who misses much," Rist speaks words that are not her own, and those words state what she *is not.* She thus is and is not the woman of Lennon's song.

In transposing the pronoun of the first line from the third to the first person (from "She" to "I"), Rist is also playing with what is commonly called a "shifter" in linguistics. A shifter is a part of language that calls attention to the speech event itself.[13] Words like "I," "Here," and "Now" make sense only when they are understood to refer to the moment and location in which they are uttered, as well as to the person who is doing the speaking. Such shifters therefore seem to attach language to the world in a direct fashion, linking a statement to the specific time and place of its utterance. The paradox of the shifter, however, is that it is also one of the least stable forms of speech. The shifter is, as Rosalind Krauss has said, "empty."[14] Any place can be a "here." Anyone can be an "I."

With such a device Rist concentrates her performance on the emptiness of a self. Speaking someone else's words, repeating a lyric that articulates a non-being (I'm *not*), and changing the pronoun to a shifter (I) that raises the predicament of an "empty" term (there is only one Rist, but *anyone* who sings the song is an I), Rist loses herself in her video. Though she is the focus of the piece, she is, at the same time, evacuating her identity. She exists in the video to the extent to which she performs a certain non-existence.

Cindy Sherman has perhaps become the most notorious artist for exercising such techniques of self-dissimulation in her work.[15] Her untitled photograph, 2000, is typical of the sort of work she has produced since the late seventies, in that it is a self-portrait in which Sherman masquerades as someone else. In the earliest example of such pieces, her black and white *Film Stills,* Sherman posed as women that one might find in movies from the fifties and sixties. In one such image she is a naïve ingénue from a small town coming to the city for the first time. In another, she is a femme fatale. But in none of the images is it possible to fix her role precisely. Her posture, outfit, and surrounding environment in such photos evoke general types from such films, but never exactly reproduce specific characters, nor are they "types" she represents completely legibly.

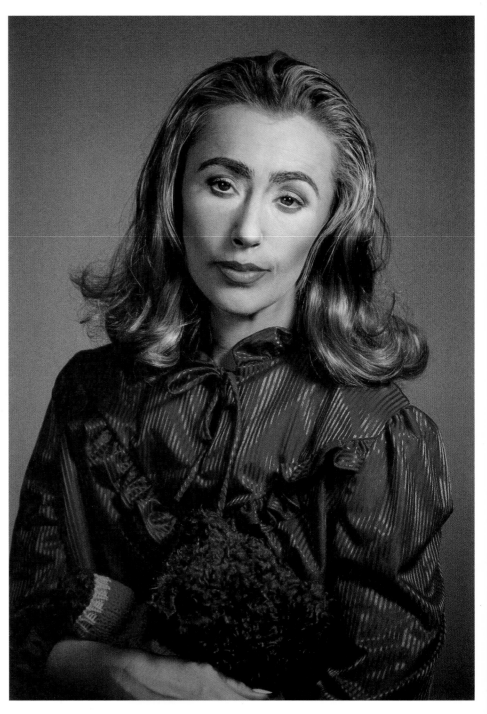

Cindy Sherman, Untitled, 2000. Cibachrome print, 32 1/2 x 22 inches. Palmer Museum of Art. Purchased with funds provided by the Donald W. Hamer Endowment for Art Acquisitions and Exhibitions, 2001.3

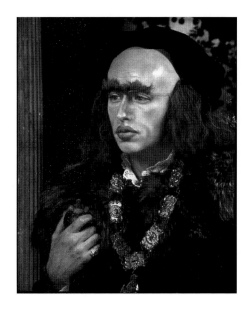

Cindy Sherman, Untitled #213, 1989. Cibachrome print, 41 1/2 x 33 inches. Collection of Alexis Shein. Photo courtesy of Metro Pictures

Sherman's recent work is similarly elusive, though the character she mimics in the work reproduced here does not come from contemporary film. Sherman strikes a Mona Lisa pose: frontal but turned slightly to her right, wearing the hint of a smile and folding her hands quietly at the base of the picture. The mystery of her expression is amplified by the ambiguity of her outfit. Her makeup and hair suggest that she is a middle-aged woman of means, but this woman (who is, in many respects, *not* Sherman) is infantilized by the puffy sleeves on her brilliant blue shirt and the stuffed animal at the bottom of the picture. Is she an eccentric wealthy woman who has never matured? Is the teddy bear her version of a lap dog? Is her placid expression a function of well-adjustment or obliviousness? The questions produced by the image are, in many respects, the pur-

pose of the piece, as Sherman's photographs demand that the viewer question the visual codes according to which class and gender are defined.

Her Untitled #213 of 1989 likewise combines different modes of representation. Like many other works from her "historical portraits" series, Sherman's image taps into styles of representation that are familiar in the annals of art history. This particular image alludes to the work of Hans Holbein and other Renaissance portraitists. At the same time, however, Sherman's presence interrupts the genre and style to which she is alluding. Sherman is cross-dressing here, occupying an outfit and pose that were typical for men of Holbein's day, though her full lips look rather womanly. The theatricality of her outfit also seems a bit wrong—in spite of

her stoic expression, her unibrow and long shaggy hair make her look clown-like, sabotaging the *gravitas* that was the usual attribute of Holbein's sitters.

While Sherman masquerades as indefinable others, Alba D'Urbano prefers to let others masquerade as her. In her 1995 work *Hautnah* (meaning "close to the skin" in German), D'Urbano first digitized images of her own body. She then arranged and printed out the resulting photographs so that they would form a sewing pattern.[16] The pattern, then, can

19

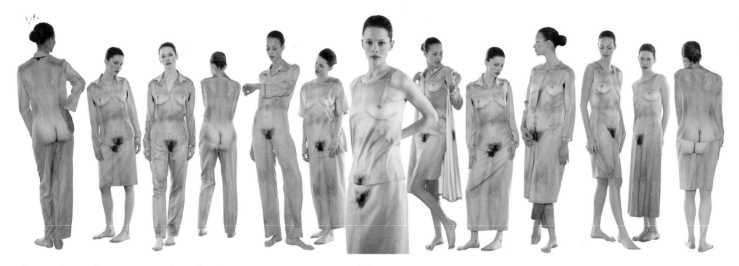

Alba D'Urbano, *Il Sarto Immortale: Collection,* 1997. Computer print on fabric. Courtesy Galerie Beekers, Frankfurt, Germany. Photo courtesy of Gerhilde Skoberne, Frankfurt

be assembled to form a sort of Alba-suit that can be worn by others. The effect is disturbing. To construct the suit, one has to puncture the image of D'Urbano's skin with a needle by running it under the ruthless jaws of a sewing machine. And the resulting hollow sculpture, the life-size simulacrum of the artist's body, seems like evidence of a flaying. Indeed, the 1991 film *The Silence of the Lambs* has encouraged such a sinister connotation of the "skin suit." In that film the villain kills and flays women so that he can construct a female outfit for himself, thus affecting a sex change he could not otherwise afford.

In spite of these more gruesome associations, there is liberating potential to the piece. More than taking a walk in someone else's shoes, one can try D'Urbano's skin on for size to see what it is like to be, among other things, D'Urbano—a woman, a body of Italian nationality. And with the editorial possibilities that accompany just about any digital image, one could ostensibly change the suit, make it expand or contract, alter its color, and add different body parts, so that the suit could accommodate anyone's body or desired body.

Skin is also a primary concern of Lesley Dill's work. In her piece *Sometimes I Feel Skinless,* 2003, which Dill created specifically for this exhibition, the artist made a brown paper mold of her face, then let what she calls a "gush" of words cascade from it. Usually her pieces include text that has

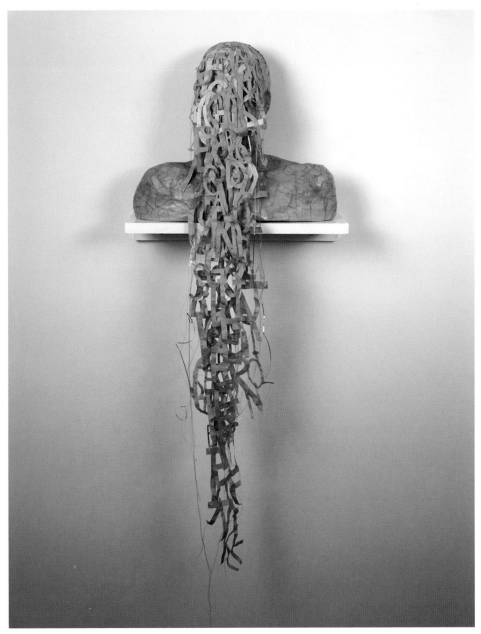

Lesley Dill, *Sometimes I Feel Skinless*, 2003. Chiri paper, wood, ink, and thread, 38 x 15 3/4 x 8 inches. Courtesy George Adams Gallery, New York

been authored by others—Emily Dickinson, Franz Kafka, or Rainer Maria Rilke, for example. This time, however, she has used a text of her own creation: "Sometimes I feel skinless and go looking for a covering" are the words that ooze out of the head like entrails toward the floor. Skin seems to be both present and absent in the work. In her self-portrait, the words describe a skinless condition, but the portrait bust offers up a sort of surrogate skin, a hollow surface, which, because of the color of the paper itself, looks pretty epidermal.

"In an unfamiliar situation, when I'm at my most vulnerable point, I feel skinless," Dill says, "but in such a situation, I also feel that there are tremendous possibilities for new forms of communication."[17] Indeed, it almost seems as if Dill might be skinless because she has offered her skin to the viewer. Shedding her skin, Dill proffers it (or at least its paper substitute) to us as a confession of her fragility, and as a gesture of communication.

Dill's piece taps into longstanding associations that have been observed between skin and speech. As *mediating* elements, both skin and language are the means by which we make contact with others, either through touch or words. They also distance us from others. As psychoanalyst Didier Anzieu has summarized:

The primary function of the skin is as the sac which contains and retains inside it the goodness and fullness accumulating there through feeding, care, the bathing in words. Its second function is as the interface which marks the boundary with the outside and keeps that outside out; it is the barrier which protects against penetration by the aggression and greed emanating from others....Finally, the third function—which the skin shares with the mouth and which it performs at least as often—is as a site and a primary means of communicating with others, of establishing signifying relations...[18]

Anzieu is speaking here of a primordial relationship between skin and communication. As an infant, a person first communicates with and gains information from the world through the touches of others *on her skin.* And, according to Anzieu, in feeding from the mother's breast the child comes into awareness of her mouth (what will eventually become the primary organ of communication) through contact with the mother's skin. It is only in later stages of development that a person distinguishes the skin from oral communication more completely.

Dill's piece might, then, speak to the ambivalent relationship between skin and speech as it can be recuperated in the adult person. If, in Anzieu's analysis, adults lose the immediate, authentic connection between skin and communication once enjoyed by the infant, Dill explores

Ana Mendieta, Untitled from the "Silueta" series, 1976. Color c-prints, 20 x 16 inches. Palmer Museum of Art, 2002.1.5,6,9. Courtesy of the Estate of Ana Mendieta and Galerie Lelong, New York

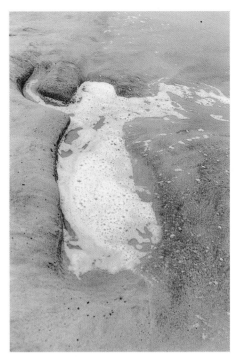

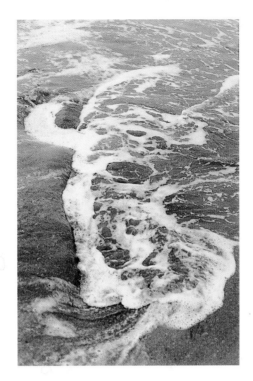

the ways in which the two might be reconnected. In a confrontation with a new experience, Dill may be out of her skin, or at a loss for words. But, in confessing that condition, by offering her skin to us, and by offering words that describe her feeling of "skinlessness," she makes an attempt at communication that is at once fragile and expressive.

Other artists in the exhibition also use self-representation as a means of exploring the "not-self." Like many of the body works that she produced in the seventies and eighties, Ana Mendieta's untitled photographic series of 1976 documents the presence and absence of her own body on a Mexican beach. Mendieta first carved a self-portrait silhouette into wet sand, achieving a form that is both a mark of her own individual body

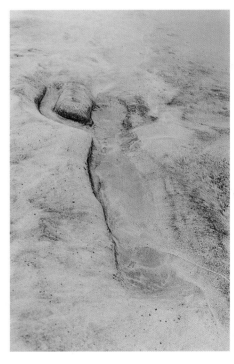

and a sort of iconic, highly coded pose reminiscent of ancient goddess figurines. Mendieta then removed herself from the sand, filled the silhouette with red pigment, and in a serial arrangement similar to many Minimalist and Conceptualist pieces of the time, photographed the silhouette's gradual erosion by the rising tide.

There are several moments of "absence" in the work. The silhouette marks the spot where Mendieta's body once was, but no longer is. With the ebb and flow of the water, the boundaries of the silhouette itself disappear. The blood-red pigment adds a disquieting quality to the piece, suggesting that the silhouette is the site of a crime in which a person was violently abducted. Those signs of absence operate on both a political and personal level. This piece and others like it have been read as a commentary on Mendieta's condition as an expatriate.[19] Mendieta left Cuba and most of her family behind at the age of 12, and she described many of her pieces according to this condition of exile, of *not-being* in respect to a place. Read according to such concerns, the "Silueta" series compares the operations of boundaries as they function in respect to a body and, simultaneously, a nation. The boundaries of Mendieta's form are impermanent, and subject to the effects of forces around it, but the boundaries of a land are no more stable. Water levels rise and sink, and the border of a country only exists in opposition to the changing boundaries of water and other countries. Both entities, Mendieta and the land itself, are porous and subject to constant redefinition, even attrition.

Recent scholarship has located a deep similarity between the condition of women and the condition of being an exile, or even a nomad. Feminist scholar Rosi Braidotti has argued that while women have historically been stereotyped as being fluid and indefinable, this "nomadic" condition might in some respects be seen as the definitive mode of being for all human beings at the end of the twentieth century. For Braidotti (who was born in Italy, raised in Australia, and educated in Paris), to be "no-madic" is to emphasize a mode of being that is constantly chang-ing. The nomad does not consider any one country to be her home, but rather traverses boundaries with ease. The nomad is a poly-glot, and understands that language is in constant flux. For the nomad, culture is an

opportunity for creative engagement and rearrangement of cultural habits and artifacts and privileges creativity over slavish observance of socio-political rules. Braidotti suggests that:

nomadic becoming is neither reproduction nor just imitation, but rather emphatic proximity, intensive interconnectedness. Some states or experiences can merge simply because they share certain attributes. Nomadic shifts designate therefore a creative sort of becoming; a performative metaphor that allows for otherwise unlikely encounters and unsuspected sources of interaction of experience and knowledge.[20]

Micaela Amato's efforts at self-portraiture enact the creative recombination of identities that Braidotti describes. Descended from Sephardic Jews who settled in Rhodes and Turkey after fleeing Spain during the 1470s, Amato cleverly reworks elements of Spanish and Mediterranean visual cultures to form contra-puntal commentaries on her own and her family's nomadic identity. In the work included here, Amato represents herself by compressing her image with a royal portrait of a princess painted by Diego Velázquez in the mid-seventeenth century.[21] Amato associates the princess both with her own Spanish ancestors and with the Spanish royalty that expelled her ances-tors from the Iberian Peninsula centuries ago. It is therefore an image that speaks to Amato's own identity as something that is based on Braidotti's "inter-

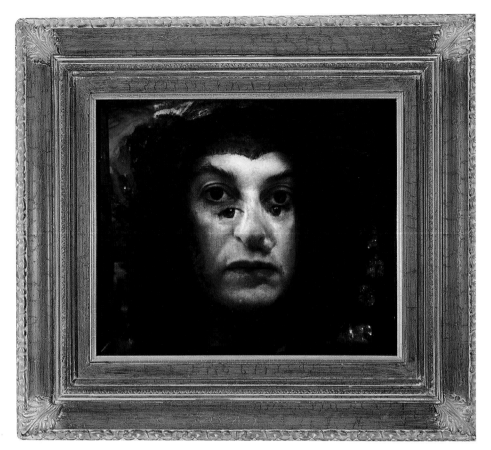

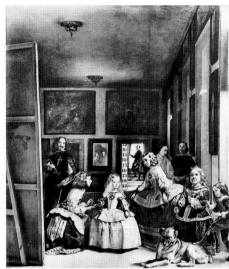

Diego Velázquez, *Las Meninas*, 1656. Oil on canvas, 126 3/8 x 110 5/8 inches. Museo del Prado, Madrid. Alinari/Art Resource, New York, NY

Micaela Amateau Amato, *Apparitional Soul (Teresa de Avila)*, 1999. Cibachrome print, 19 1/2 x 23 1/2 inches. Palmer Museum of Art. Anonymous gift, 2002.100

connectedness"—a self that is mediated by her relationship to multiple locations and times.

Her reference to Velázquez also cleverly calls attention to Amato's own nimble accomplishments as an artist. The portrait of the princess was part of a larger project of royal portraiture that

kept Velázquez employed for his entire career.

In larger works from that same time period, such as his famous *Las Meninas* of 1656, Velázquez purposefully complicated the relationship between self-portrait and royal portrait.

Velázquez represents himself at the left of *Las Meninas,* and he appears to be finishing the portrait of… someone. It may be a portrait of King Philip and Queen Isabella; it seems that their faces are reflected in a mirror at the back of the room, in which case they are standing in front of the picture (occupying

our position in front of it), posing for the portrait. That image at the back, however, may actually be a finished portrait hanging on the wall, in which case Velázquez must be working on someone else's likeness. The princess appears front and center in the image, though if Velázquez is painting her likeness, she is facing the wrong way. While it seems, then, that Velázquez in the picture cannot be painting the portrait of the king, queen, or princess, he actually succeeds in making a portrait of all three, for the finished painting of *Las Meninas* documents them all (just as it documents his own presence). The confusion of gazes and the ambiguity of poses leave at least one thing clear—Velázquez is the master of the situation, recording the royal family while at the same time demonstrating his skills as he calibrates several portraits in a single brilliant image.

In referencing Velázquez in the context of (self)portraiture, Amato alludes to the power of the artist to play on conventions of representation, particularly in the Spanish tradition to which she feels historically and genealogically linked. In the process, she condenses the complex workings of her Baroque predecessor by overlapping and amalgamating images. Indeed, rather than dispersing portraits and sending the viewer on a circuitous route from potential sitter to potential sitter (as Velázquez does in *Las Meninas*), Amato condenses portraits and unites them in a palimpsest of selves. The resulting image is both autobiographical in terms of her own family history, and profoundly art historical in its self-conscious allusions to conventions of portraiture.

Frequently, self-representations by artists interpolate the viewer as well as previous artists. Such is the case with Carrie Mae Weems' "Kitchen Table" series, one photograph from which appears in this exhibition. Like most other images in the series, this photograph features a female character (played by Weems) seated at a kitchen table, though in other images more characters in different scenarios might accompany her. As Dana Friis-Hansen has observed, each photograph of the series leaves a space open at the end of the table for the viewer.[22] The resulting image creates a hospitable space in which the viewer is invited to participate in narratives that draw heavily from popular films, soap operas, and novels.

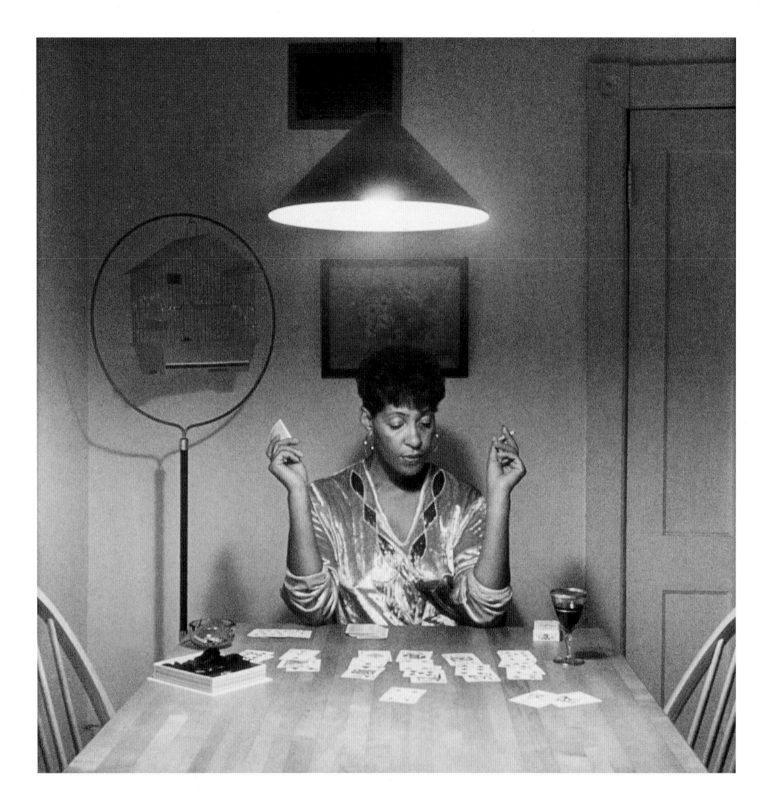

At times this open space for the viewer provides an opportunity for Weems to play with notions of dialogue between artist and spectator. In the untitled photograph in the Palmer collection, for example, Weems' character is playing solitaire. As she smokes a cigarette in a windowless room, this woman seems to be an insomniac housewife passing time. At the same time, however, her symmetrical pose and the light above her head give her the quality of a priestess—a characterization that allows her game of cards to seem less of a mundane enterprise and more, perhaps, a sacred ritual. This woman may, in essence, be *reading our cards,* telling our fortune, or describing our personal traits to us. The photograph thus shifts back and forth between being an isolated scene in which Weems is subject to the gaze and interpretive power of the viewer, and a more dialogic scene in which the viewer is subject to Weems' own interpretive powers in respect to us.

Catherine Opie insists on a more brutal dialogue between artist/ sitter and viewer in her *Self-Portrait/Pervert* of 1994. Masked in leather, pierced on multiple sites up and down her arms, and with the word "pervert" etched onto her chest (a word enhanced by the bloody garland motifs that mimic the wallpaper behind her), Opie's body develops a sado-masochistic relationship to the viewer in which she plays a submissive role.

Sado-masochistic relationships are not new to contemporary portraiture.[23] Robert Mapplethorpe famously filtered conventions of portraiture through rituals of bondage in his 1979 photograph of Brian Ridley and Lyle Heeter.

Bracketed by the bric-a-brac-covered mantelpiece and the kitschy deer antler side table, Brian and Lyle, deadpan and leather-clad, occupy a subtly camped-up version of a suburban homestead. Just as their surroundings reference, but then slightly tweak, middle American décor, so their pose also puts a twist on traditions of representing the usual inhabitants of such spaces. Their pose is familiar; it is commonplace for a portrait of a couple to feature one figure standing and one figure seated. However, the difference between those two positions is usually gendered, as the standing figure is typically the man of the house,

29

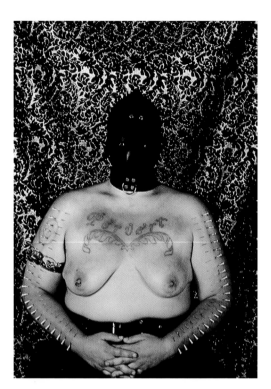

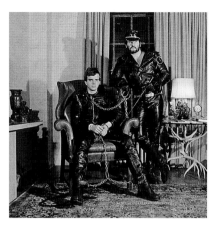

Robert Mapplethorpe, *Brian Ridley and Lyle Heeter*, 1979. Gelatin silver print. Copyright ©Robert Mapplethorpe Foundation

Catherine Opie, *Self-Portrait/Pervert*, 1994. Chromogenic print, 40 x 30 inches. Collection of Patricia A. Bell

while the wife sits. Mapplethorpe's photo translates this binary, male/female arrangement of gender into new terms—the "top," or dominant member of the couple, and the "bottom," or masochistic member. This slight shift from the male/female pairing to the top/bottom pair recasts the power that operates within relationships from something that is supposedly biological to

something that is explicitly behaved. In other words, Brian occupies his position in the portrait not because of any physiological attributes of his body, but rather because of what he chooses to do with, and enjoys doing with, his body in relationship with Lyle. This subsequent reinterpretation of power and pleasure in couples (which adds new meaning to

the phrase "the old ball and chain") by extension troubles the presumed naturalness of any relationship in a portrait. To look at any portrait of man and wife, then, is to understand that gender is performed through conventions such as those that operate in portraiture. A man defines his masculinity by virtue of the position he occupies; standing is a means of performing that gender role.

Opie shifts the power relationship in portraiture from the third person to the second person. Rather than showing a scene in which the external viewer is witness to a top/bottom relationship, Opie addresses her own masochistic posture towards us—making us, in essence, the top in the couple. Further, Opie intensifies and complicates the relationship by displaying a much more painful position. The image might therefore also be considered sadistic, as it challenges the viewer to gaze at a scene that might be rather painful to look at.

Just as Mapplethorpe's image challenges the natural power relationships at work in couples, as well as the operations of gender and sexuality that steer the traffic of desire between them, so Opie's image also destabilizes the ways in which the viewer might think of women, particularly lesbian women, as victims of violence or discrimination. Summarizing relationships between masochism and power, cultural critic Michael Uebel suggests that the masochist makes a mockery of political domination. Uebel argues:

…masochism works by calling into being the very Law…. So from outside the politico-libidinal matrix of master/slave, it looks as if masochism involves only the sacrifice of one's own enjoyment. However, from within, the masochist reveals the truth of symbolic power: subordination to the exact letter of the Law, thereby exaggerating its obscene dimension, subverts the very meaning of regulation.[24]

In other words, the masochist makes a masquerade of power itself, playing at the rituals of repression and domination to such an extent that power appears to be less authentic and more of a performative maneuver. In this sense, Opie's body in the image assumes a legibly masochistic position and dramatizes the social stigma often attached to the lesbian body. As a kinky form of passive resistance, in choosing to assume a submissive role, Opie challenges the viewer to investigate his or her own motivations in agreeing to assume a sadistic position. Further, Opie libidinizes the domination of women by suggesting that she might take pleasure in the trappings of domination, and in the process, disarms those who might enjoy the domination of women's bodies against their will. In this highly problematic maneuver, she likewise introduces the (often heterosexual) viewer to rituals of bondage and domination that signify forms of sexuality with which that viewer might be unfamiliar and uncomfortable.

Joan Semmel's larger-than-life self-portrait also confronts the viewer in a full frontal pose, though her position of direct address complicates the relationship between viewer and viewed. Like her recent *Knees Together* of 2003, most of the paintings that Semmel has produced since the early seventies have documented the artist's *own* gaze upon her body. Those earlier paintings reproduced a sight with which virtually all women are familiar—the top-down view of one's own body in which one sees the tops of one's breasts, then the stomach, knees, and feet. Such images rebelled against conventions of the female nude in which women's bodies were typically subjected to the male gaze.[25] In traditional nudes, the woman is often laid out at a bit of a distance, and the pictured woman addresses the

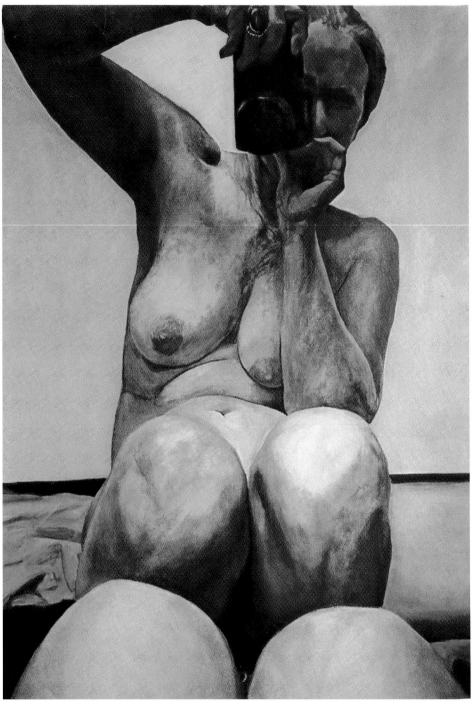

Joan Semmel, *Knees Together*, 2003. Oil on canvas, 60 x 48 inches. Courtesy Mitchell Algus Gallery

viewer with a come-hither look meant specifically to seduce male viewers who usually purchased such canvases. By contrast, Semmel's paintings offered viewers a woman's awareness of her *own* body as something that is an agent for action, rather than a merely passive recipient of male desire.

In those earlier images Semmel's head did not, of course, appear, as one can't very well look at one's own face without the mediating presence of something like a mirror. Further, those images often claimed a certain immediacy for the-woman-as-spectator, by arguing that a woman could directly confront her body and circumvent sexist modes of viewing in which women were subjected to male viewpoints. But in the images made over the past few years, Semmel seems increasingly interested in the notion that one's relationship to oneself is often mediated. For example, in *Knees Together* there are several objects that intervene between Semmel and herself: the looking glass that provides a reflection of her body, a camera that documents the reflection, and the resulting painting that reproduces the photographed reflection. In this respect, Semmel's self-portrait is, truly, a walk through the looking glass—a site of multiple reflections and representations that speak to the circuitous means by which one knows one's own body.

Indeed, Semmel's body seems to reflect itself through formal repetitions in the work. On her right hand an oval ring forms the apex of her body as it is reflected in the mirror—a round shape that is doubled by the camera lens. Then, in the mirror image, two breasts descend from her body, to be rhymed by her two knees, which are then repeated by Semmel's knees that are not the reflection, but, rather, are her two "real" knees pressed against the mirror plane. Semmel's body then is an abundance of circular forms that repeat themselves and cascade outward toward the viewer.

As the title suggests, Semmel's knees are thus "together," but in more than one sense. Her knees are "together" in that her "real" knees and their reflected image push against each other. But Semmel also keeps her knees together as any woman does in moments of modesty—a modesty that is gleefully mocked by Semmel's shameless display of her body.

"And now, who am I?"

The epigraph for this essay comes from chapter three of Lewis Carroll's *Through the Looking Glass.* It is a question that Alice poses when she enters a magical forest in which nothing has a name. She asks this question after having first traveled through a mirror, the most familiar kind of device for self-representation. Contrary to what one might otherwise expect, in the mirror, or on the other side of it, Alice does not find herself—only challenges (like the forest) to her sense of reality and her own identity. The mirror is a conduit to a world in which selfhood is a riddle. In some respects, most of the artists in this exhibition see self-representation as a similar dilemma. When Joan Semmel stares into a looking glass, the resulting painting is not an answer but another way of asking "who am I?" Like Semmel, for most of these artists self-representation reflects and even begins a process of unraveling the presumptions of selfhood.

Unlike Alice in the forest, however, when the artists of this show ask, "who am I?," it is not only part of an internal monologue. Nor is it a question asked with the presumption that an answer will eventually be forthcoming (if only when one leaves the forest, for example). Rather, it is often a challenge posed to us as viewers. It is a question asked in defiance of any attempt to fix them within a confining definition. In the process, these artists keep the question of identity open long enough so that we might also think about the ways in which we habitually answer that question about other people. And, if looked at carefully, these artists may inspire within any viewer a similar curiosity, and bravery, so that we might ask that question about ourselves.

Sarah K. Rich, guest curator

Endnotes

[1] Denise Riley, *Am I That Name?: Feminism and the Category of "Women" in History* (Minneapolis: University of Minnesota, 1988), 1–2.

[2] For a much more nuanced discussion of essentialist/historicist debates regarding gender in art history, see Norma Broude and Mary D. Garrard, "Feminism and Art in the Twentieth Century," in *The Power of Feminist Art: The American Movement of the 1970s, History and Impact,* ed. Norma Broude and Mary D. Garrard (New York: Harry N. Abrams, 1994), 10–29.

[3] See, of course, Linda Nochlin's germinal essay, "Why Have There Been No Great Women Artists?," in *Women, Art and Power: and Other Essays* (New York: Harper and Row, 1988), 145–75.

[4] For the most astute description of the ways in which sexuality operates in the definition of gender, see Judith Butler, *Gender Trouble: Feminism and the Subversion of Identity* (New York: Routledge, 1990). Butler refutes biological definitions of gender and argues that gender is, rather, performed. In other words, one is a "woman" to the extent to which one carries the trappings of "woman," acts according to (or against) certain codes of behavior for "woman," and, most importantly, expresses desire for other bodies in a way that may (or may not) be typical of a "woman."

[5] Mary D. Garrard makes this comparison in her article "Artemesia Gentileschi's Self-Portrait as the Allegory of Painting," *Art Bulletin* 62 (March 1980): 97–112. See also Frances Borzello, *Seeing Ourselves: Women's Self-Portraits* (New York: Harry N. Abrams, 1998), 53–56.

[6] Rosler discusses the series in an interview with Benjamin Buchloh in the recent retrospective catalog *Martha Rosler: Positions in the Life World,* ed. Catherine de Zegher (Cambridge, Mass.: MIT Press, 1998).

[7] For a discussion of such interior shots in which fine art appears in conjunction with post-war interior design, see Cécile Whiting, "Pop at Home," in *Not at Home: The Suppression of Domesticity in Modern Art and Architecture,* ed. Christopher Reed (New York and London: Thames and Hudson, 1996), 222–36.

[8] Yayoi Kusama in conversation with Gordon Brown, 1965, reprinted in Laura Hoptman, Akira Tatehata, and Udo Kultermann, *Yayoi Kusama* (London: Phaidon Press, 2000), 103.

[9] Though she does not discuss the connection between Kusama and Pop art at great length, Laura Hoptman mentions that Kusama appeared in Lucy Lippard's survey of Pop art in 1966, and briefly connects Warhol, Oldenburg, and Kusama in her "Survey," in *Yayoi Kusama,* especially 56–59.

[10] Conversation between Brown and Kusama.

[11] Peggy Phelan, "Opening Up Spaces within Spaces: The Expansive Art of Pipilotti Rist," in Hans Ulrich Obrist, Peggy Phelan, et al., *Pipilotti Rist* (London: Phaidon Books, 2001), 42–45.

[12] For a close reading of the song, see Tim Riley, *Tell Me Why: A Beatles Commentary* (Cambridge, Mass.: Da Capo Press, 2002), 268–71.

[13] Shifters were famously described by Roman Jakobson in his 1956 paper, "Shifters, Verbal Categories, and The Russian Verb," reprinted in *Roman Jakobson, Selected Writings,* Vol. II (The Hague: Monton, 1971), 130–47.

[14] Rosalind E. Krauss, "Notes on the Index, Part I," in *The Originality of the Avant-Garde and Other Modernist Myths* (Cambridge, Mass.: MIT Press, 1985), 197–209.

[15] An extensive bibliography has been accumulated around Sherman's work. For an effective summary of Sherman's efforts and a listing of current bibliography, see the recent retrospective, Amanda Cruz, et al., *Cindy Sherman*, Los Angeles Museum of Contemporary Art (New York: Thames and Hudson, 1997).

[16] D'Urbano describes the process in an artist's statement published in Hubertus von Amelunxen, et al., *Photography after Photography: Memory and Representation in the Digital Age* (Amsterdam: G & B Arts, 1996), 270–75.

[17] Phone conversation with the author, June 3, 2003.

[18] Didier Anzieu, *The Skin Ego: A Psychoanalytic Approach to the Self,* trans. Chris Turner (New Haven: Yale University Press, 1989), 40. This passage is quoted by Kathy O'Dell in her recent discussion of Vito Acconci in her *Contract with the Skin: Masochism, Performance Art, and the 1970s* (Minnesota: University of Minnesota Press, 1998), 20–21.

[19] Jane Blocker, for example, reads many of Mendieta's pieces according to the ideologies of boundary marking and the condition of exile in her *Where is Ana Mendieta?: Identity, Performativity and Exile* (Durham and London: Duke University Press, 1999).

[20] Rosi Braidotti, *Nomadic Subjects: Embodiment and Sexual Difference in Contemporary Feminist Theory* (New York: Columbia University Press, 1994), 5–6.

[21] For a detailed description of Amato's recent work, see Robert Mattison, "Micaela Amato: A Healing Garden," *Woman's Art Journal* 22 /1 (Spring/Summer 2001): 40–43.

[22] Dana Friis-Hansen, *Carrie Mae Weems: The Kitchen Tables Series* (Houston: Contemporary Arts Museum, 1996), 7.

[23] See also Deborah Bright, ed., *The Passionate Camera: Photography and Bodies of Desire* (New York: Routledge, 1998).

[24] Michael Uebel, "Masochism in America," *American Literary History* 14/2 (Summer 2002): 397–98. Uebel's discussion of the political implications of masochism derive in part from his reading of a key text on this subject, Theodor Reik, *Masochism in Modern Man,* trans. Margaret Biegel and Gertrud Kurth (New York: Farrar, 1941).

[25] For an excellent summary of Semmel's project as it related to feminism in the 1970s, see Joan Marter, "Joan Semmel's Nudes: The Erotic Self and the Masquerade," *Woman's Art Journal* 16/2 (Fall 1995/Winter 1996): 24–28.

Checklist of the Exhibition

Micaela Amateau Amato
(American, b. 1945)
Apparitional Soul (Teresa de Avila),
1999
Cibachrome print
19 1/2 x 23 1/2 inches
Collection of Palmer Museum of Art
Anonymous gift
2002.100

Lesley Dill (American, b. 1950)
Sometimes I Feel Skinless, 2003
Chiri paper, wood, ink, and thread
38 x 15 3/4 x 8 inches
Courtesy George Adams Gallery,
New York

Alba D'Urbano (Italian, b. 1955)
Il Sarto Immortale: Dress, 1997
Computer print on fabric
18 x 46 inches
Courtesy Galerie Beekers, Frankfurt,
Germany

Yayoi Kusama (Japanese, b. 1929)
Multi-fabrics by Yayoi Kusama, 2002
Fabric cover, collage with photo-
graph by Hal Reiff of the artist
reclining on *Accumulation No. 2,*
1966, cotton and polyester
86 5/8 x 110 1/4 inches
©Yayoi Kusama, Courtesy Robert
Miller Gallery, New York

Ana Mendieta (American, b. Cuba,
1948–1985)
Untitled from the "Silueta" series,
1976
Suite of nine color c-prints
5 sheets 16 x 20 inches; 4 sheets
20 x 16 inches
Collection of Palmer Museum of Art
2002.1.1–9

Catherine Opie (American, b. 1961)
Self-Portrait/Pervert, 1994
Chromogenic print
40 x 30 inches
Collection of Patricia A. Bell

Pipilotti Rist (Swiss, b. 1962)
I'm Not the Girl Who Misses Much,
1986
Single channel video
5 minutes, color
Sound: "Happiness is a Warm Gun"
by John Lennon/Paul McCartney

You Called Me Jacky, 1990
Single channel video
4 minutes, color
Sound: Kevin Coyne

Blutclip (Bloodclip), 1993
Single channel video
2 minutes, 25 seconds; color
Sound: Sophisticated Boom Boom

All videos courtesy of the artist and
Luhring Augustine, New York

Martha Rosler (American, b. 1943)
Self-Portrait I, from the "Body Beautiful" (a.k.a. "Beauty Knows No Pain") series, 1966–72
C-print
14 3/4 x 19 1/2 inches
Collection of the artist, courtesy of Gorney Bravin + Lee, New York

Martha Rosler (American, b. 1943)
Self-Portrait II (Lost in the City), from the "Body Beautiful" (a.k.a. "Beauty Knows No Pain") series, 1966–72
C-print
15 x 15 inches
Collection of the artist, courtesy of Gorney Bravin + Lee, New York

Martha Rosler (American, b. 1943)
Semiotics of the Kitchen, 1975
Video, 6 minutes, 9 seconds, black and white, sound
Courtesy of Electronic Arts Intermix (EAI), New York

Cindy Sherman (American, b. 1954)
Untitled #213, 1989
Cibachrome print
41 1/2 x 33 inches
Collection of Alexis Shein

Cindy Sherman (American, b. 1954)
Untitled, 2000
Cibachrome print
32 1/2 x 22 inches
Collection of Palmer Museum of Art
Purchased with funds provided by the Donald W. Hamer Endowment for Art Acquisitions and Exhibitions
2001.3

Joan Semmel (American, b. 1932)
Knees Together, 2003
Oil on canvas
60 x 48 inches
Courtesy Mitchell Algus Gallery

Carrie Mae Weems (American, b. 1953)
Untitled (Solitaire) from the "Kitchen Table" series, 1990
Gelatin silver print
28 1/4 x 28 1/4 inches
Collection of Palmer Museum of Art
Museum purchase and partial gift from the Friends of the Palmer Museum of Art
2002.64